Do You Like Fuck Off?

Beautiful Swear Word To Color For Stress Releasing

Chase C. Demon

by Chase C. Demon

...dwide. No part of this publication may be reproduced or ...any form or by any means, mechanical, electronic or stored in a ...al or database system, without written permission from the copyright holder.

Happy Coloring!

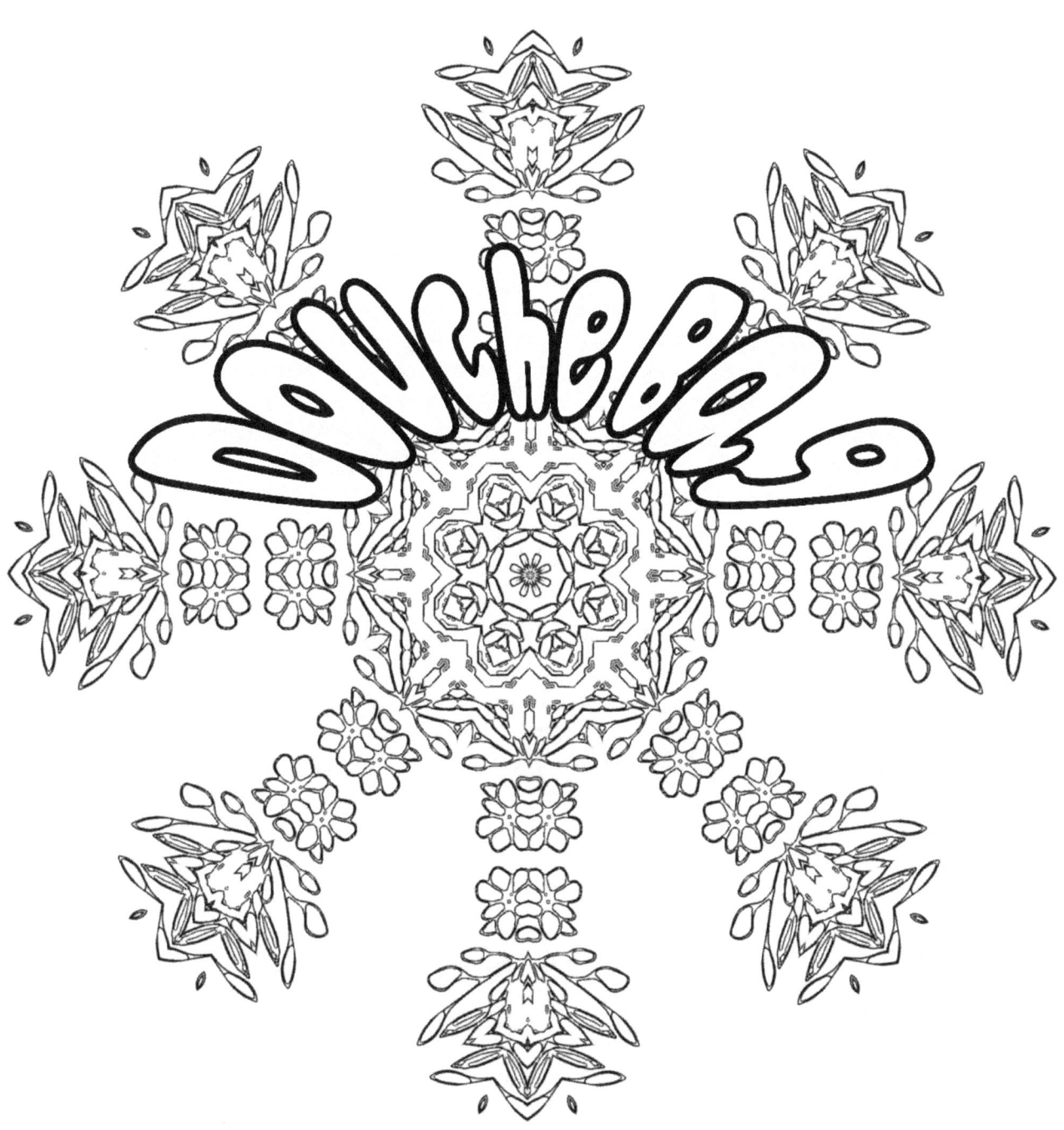

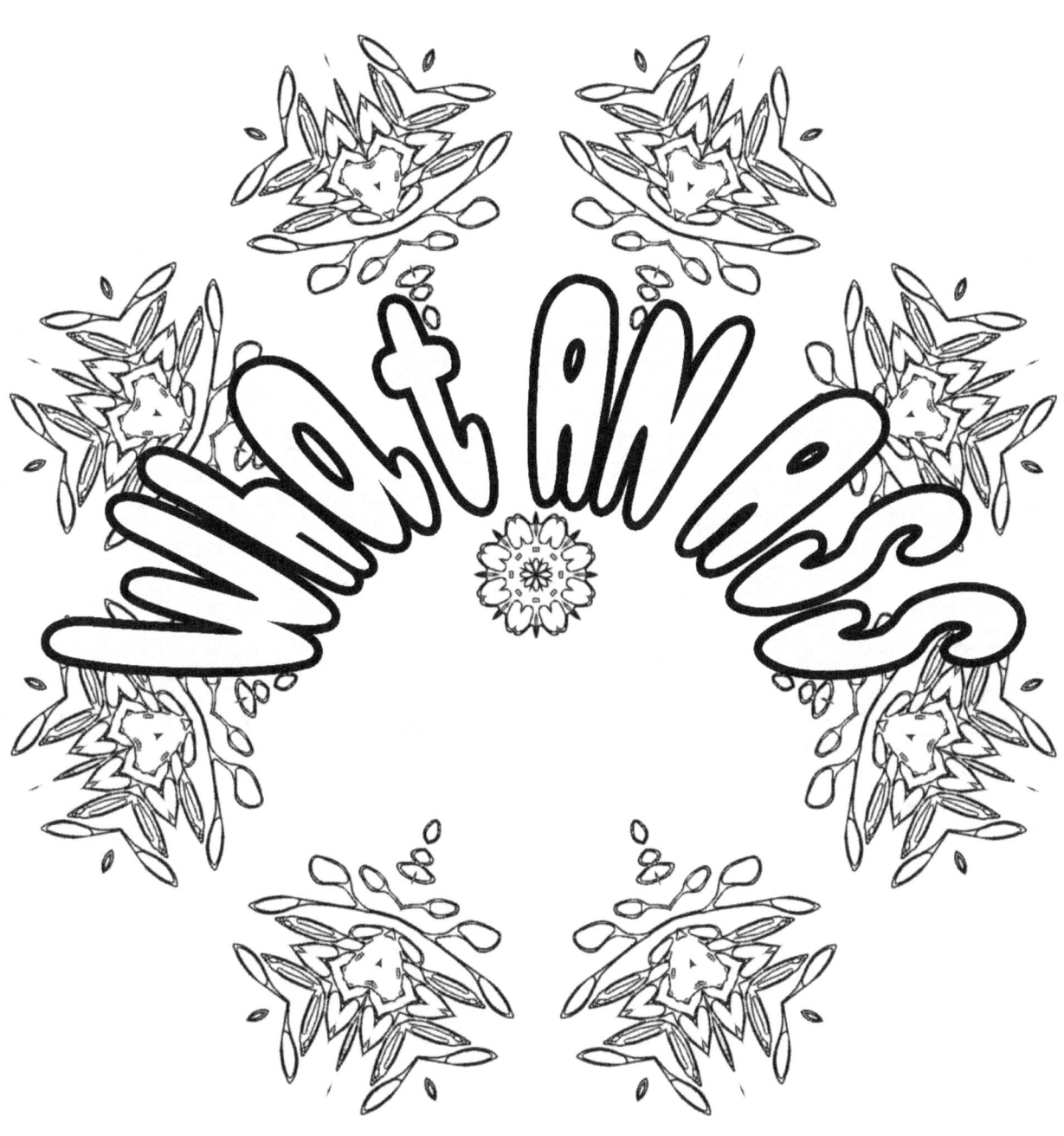

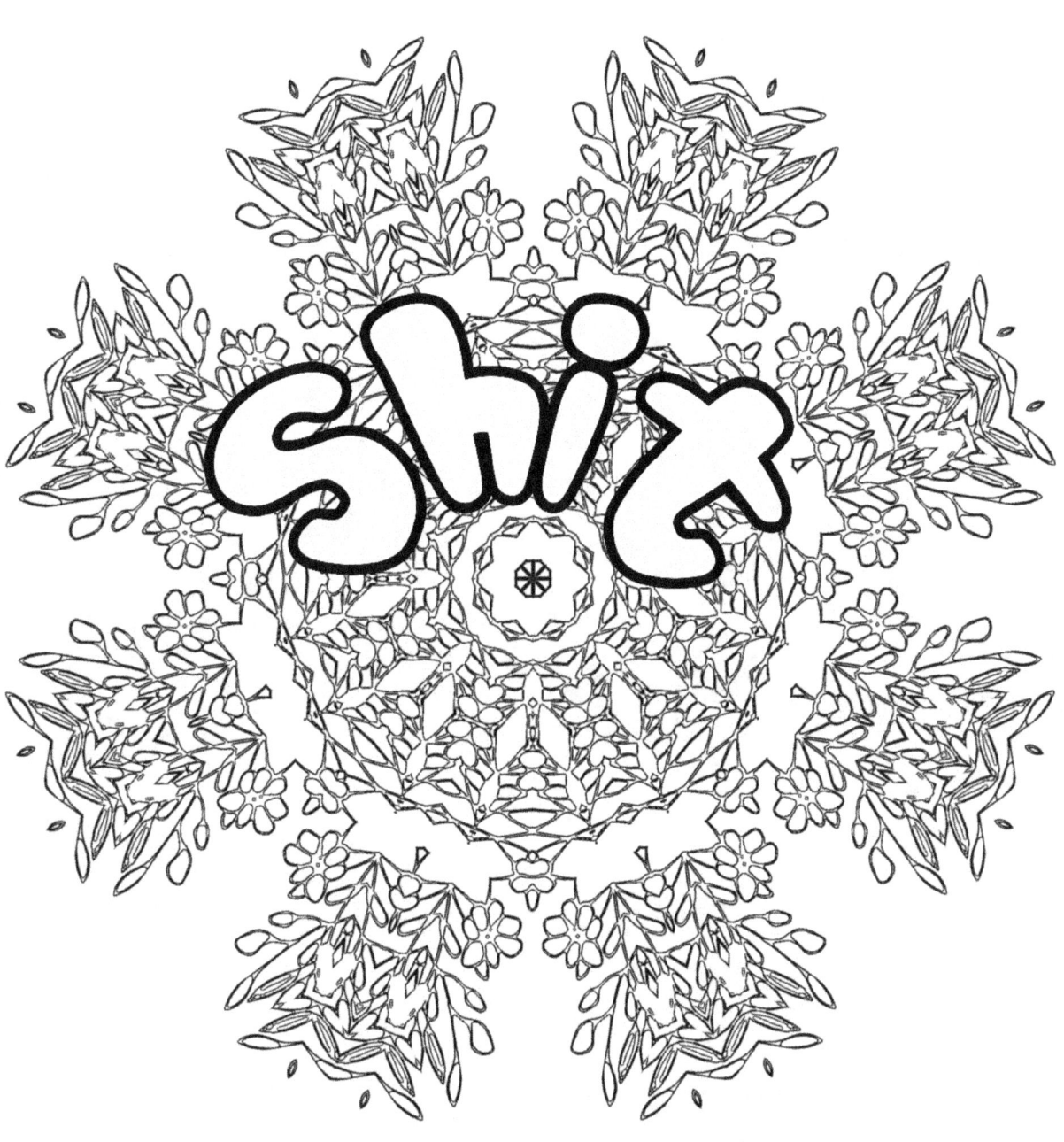

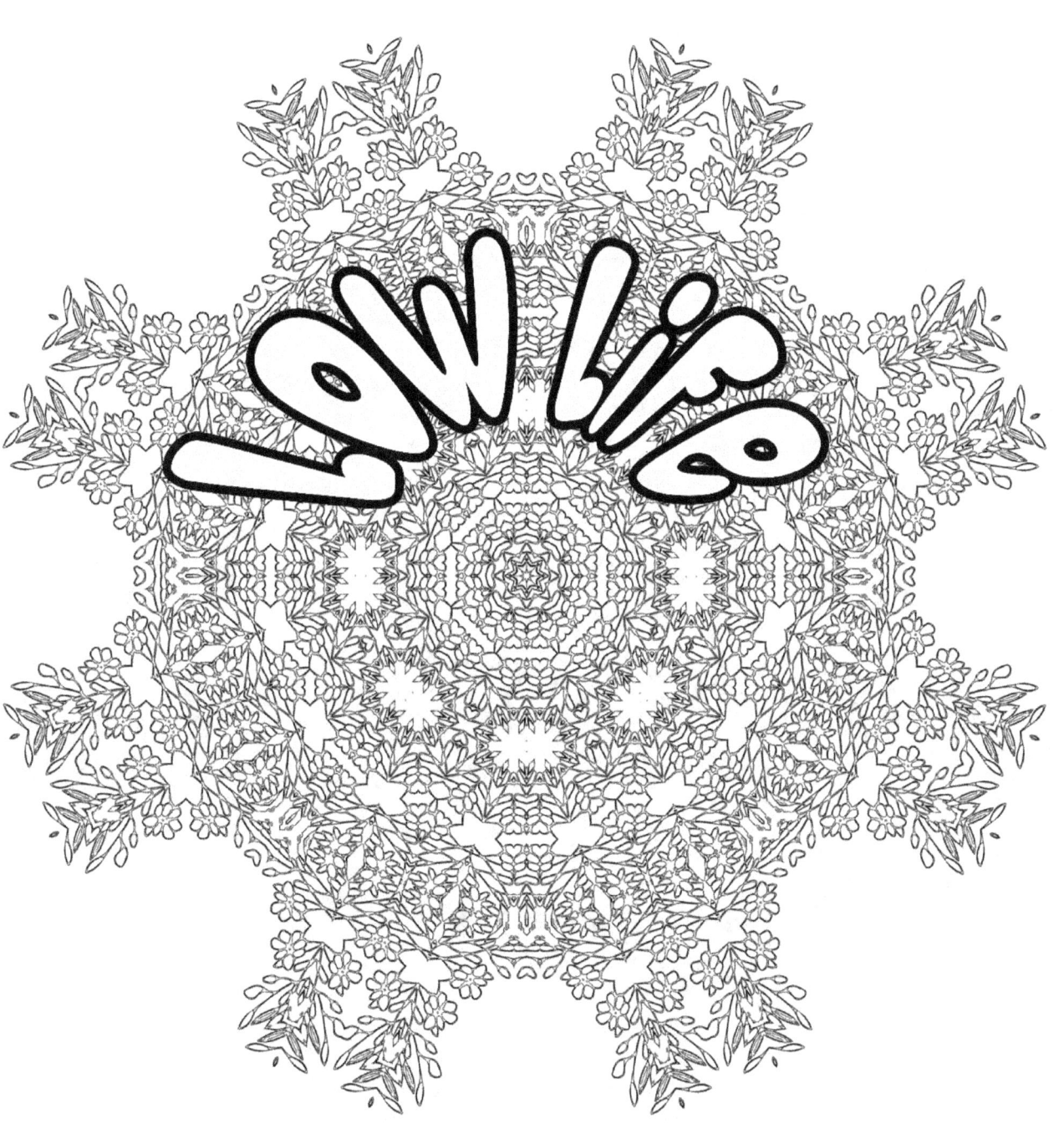

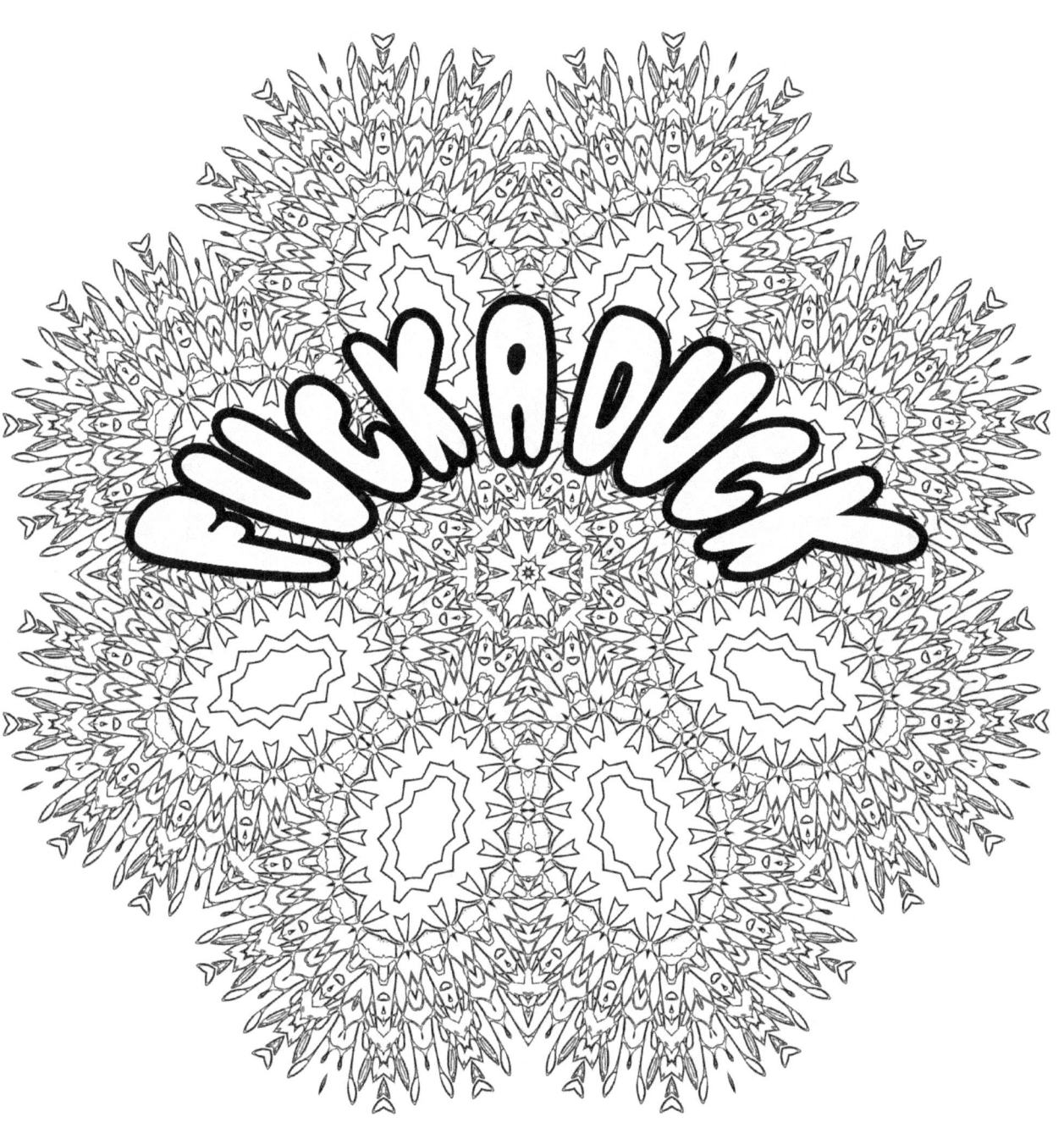

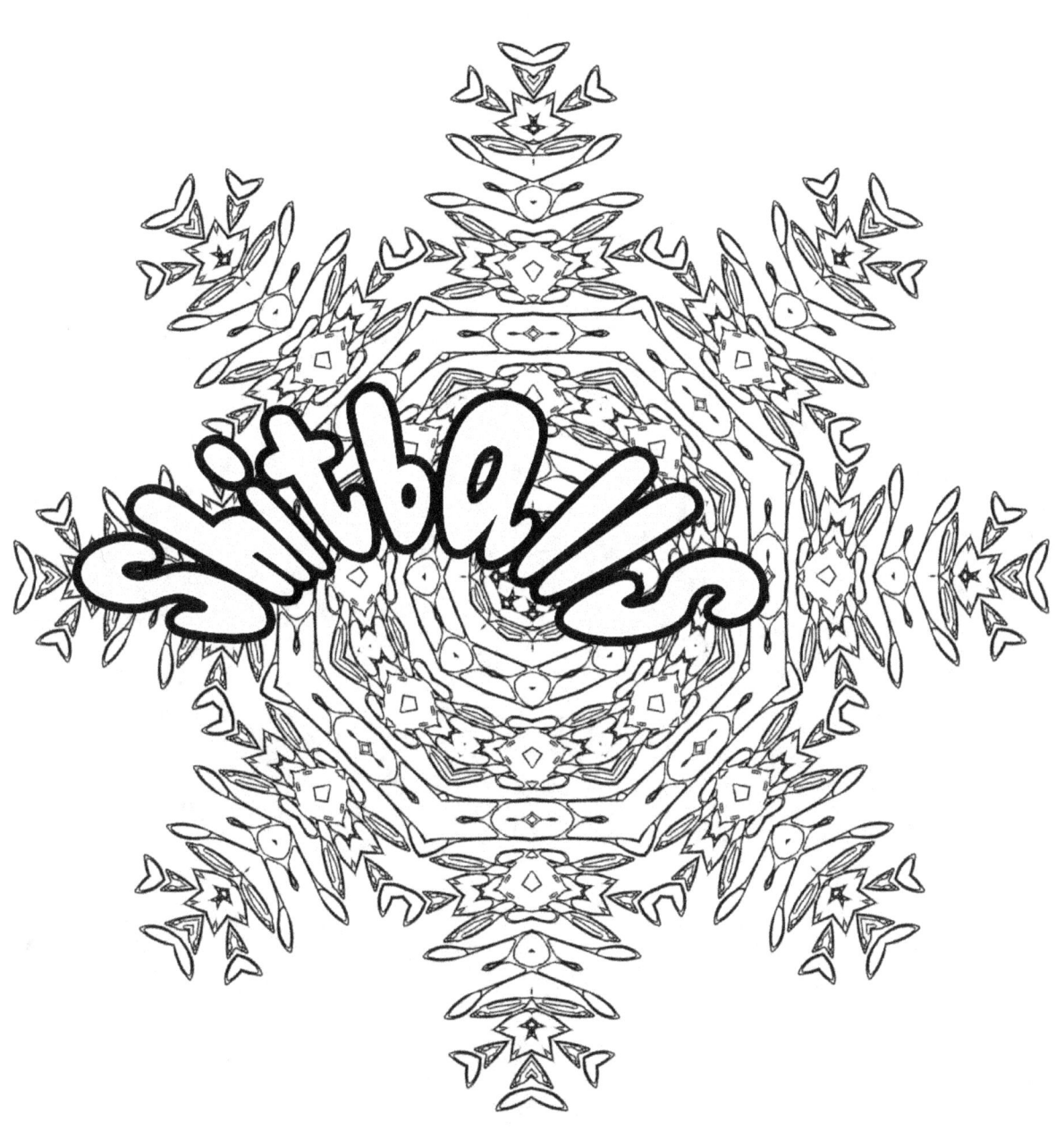

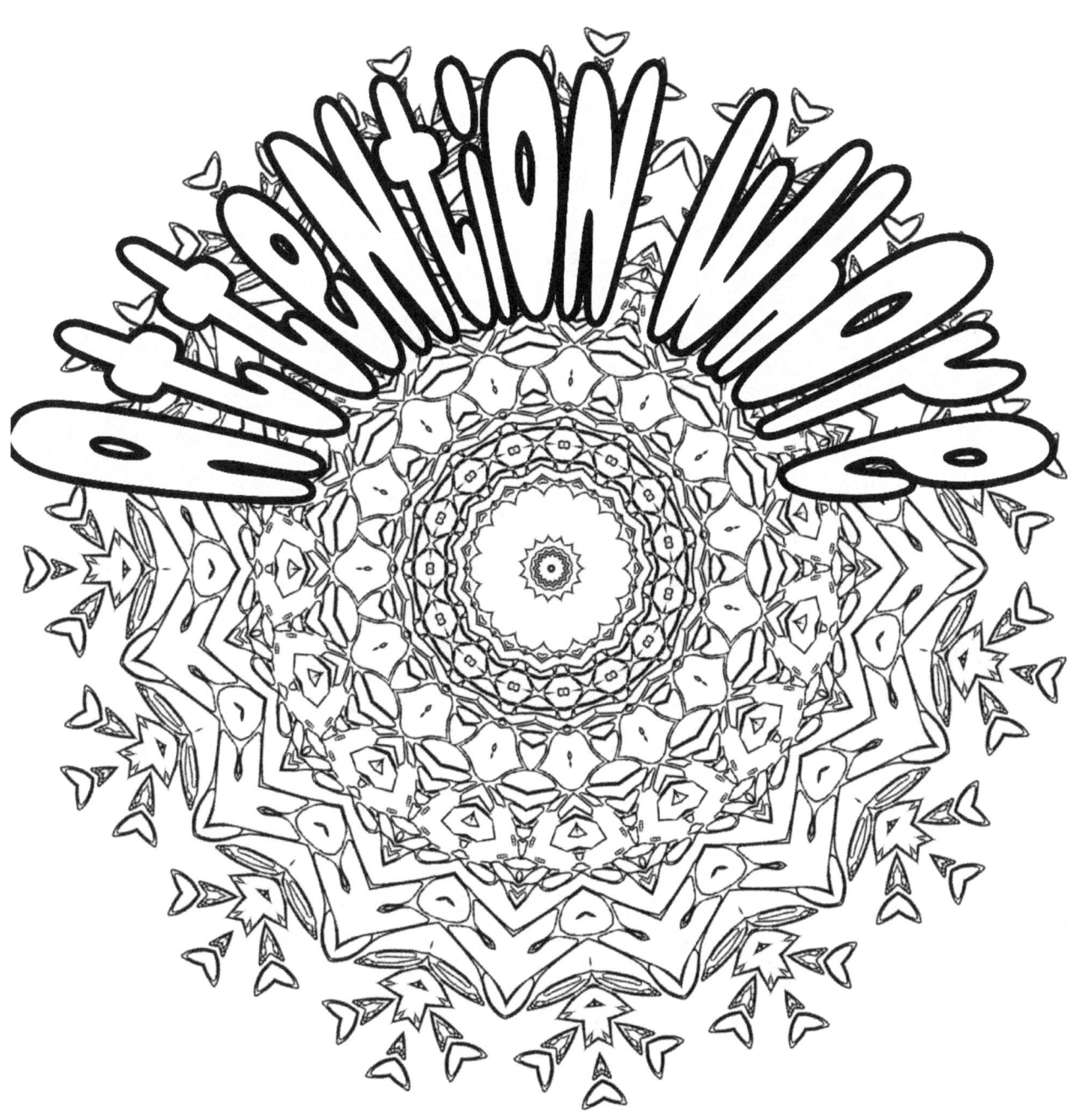

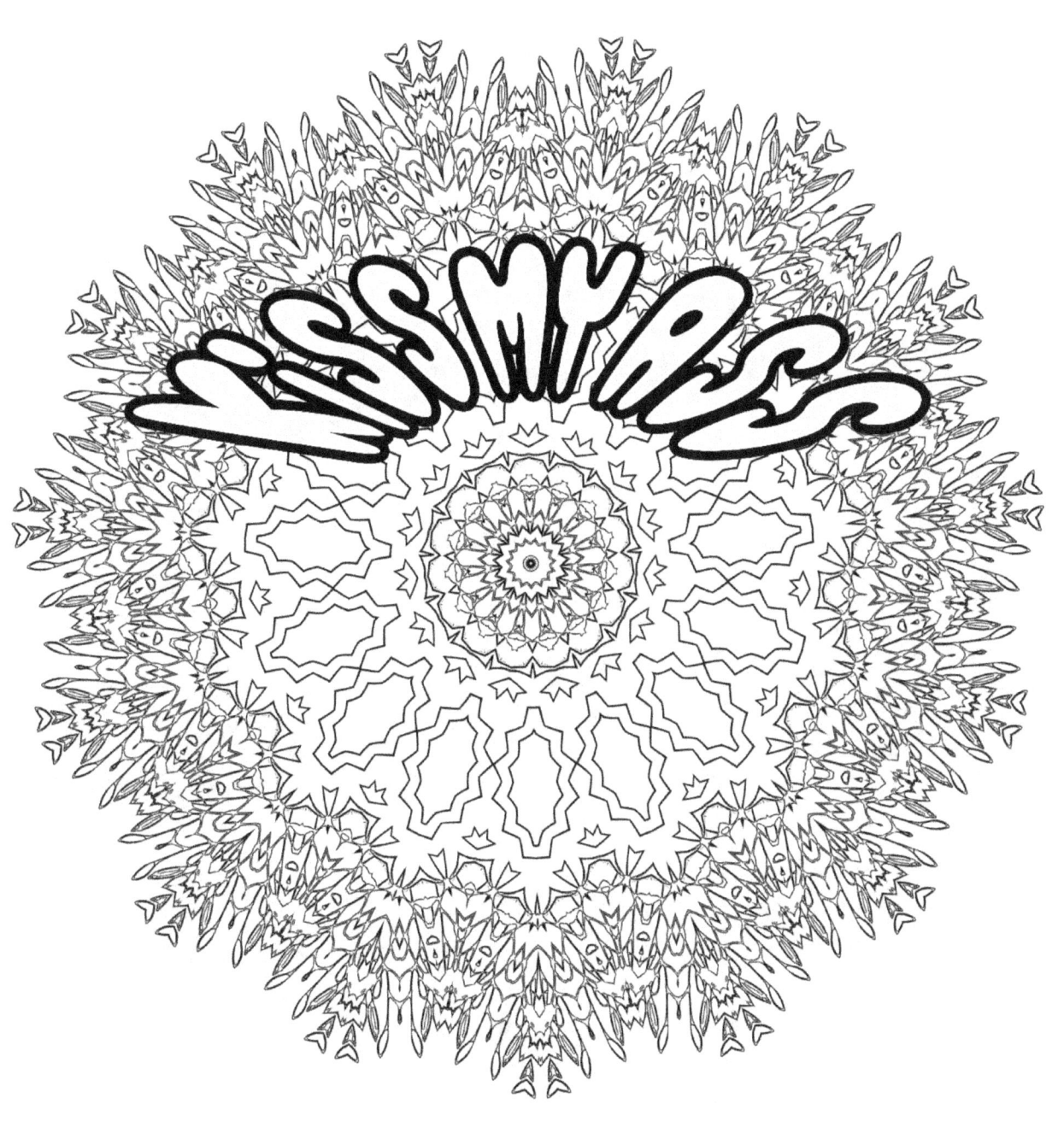

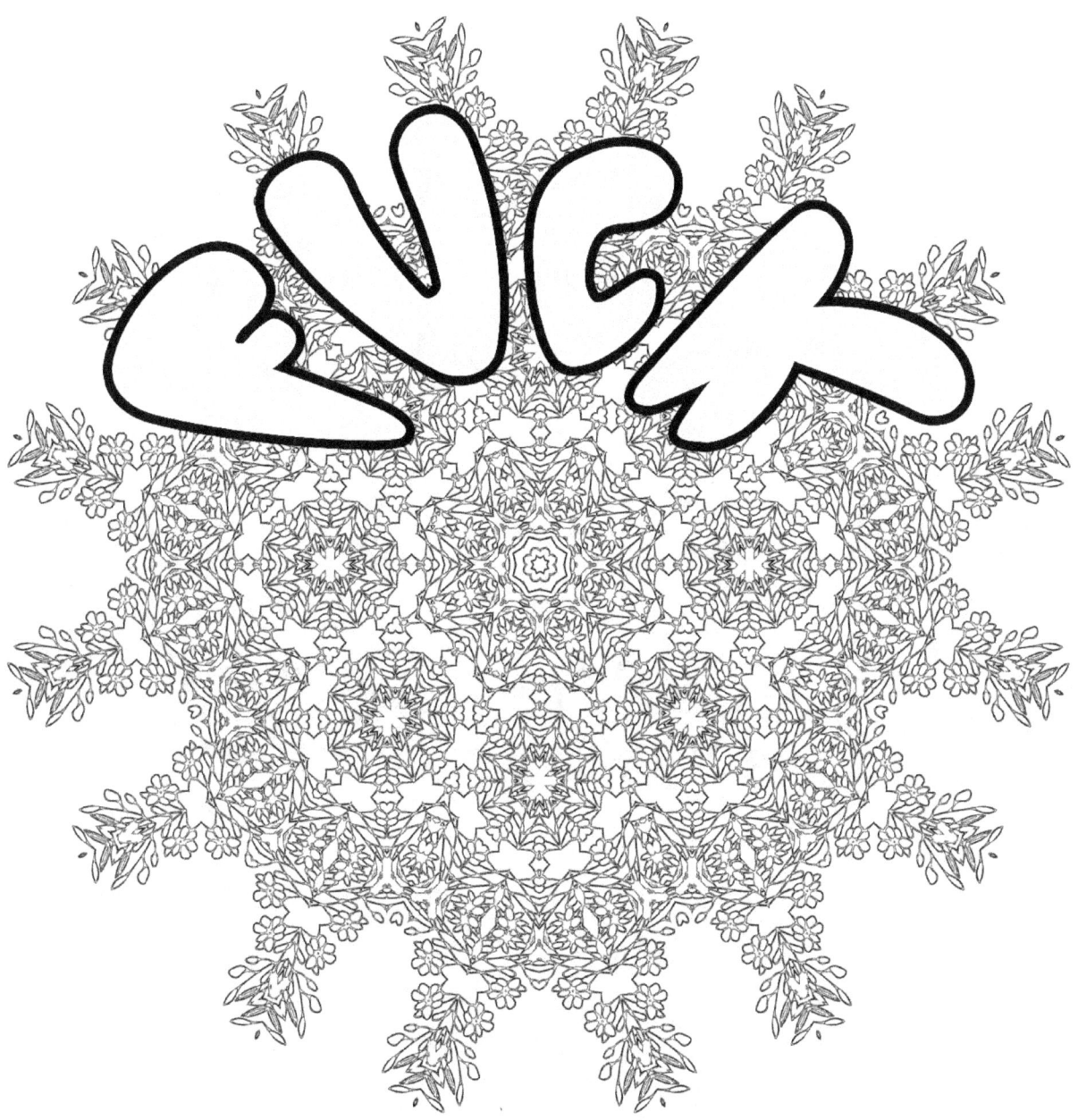

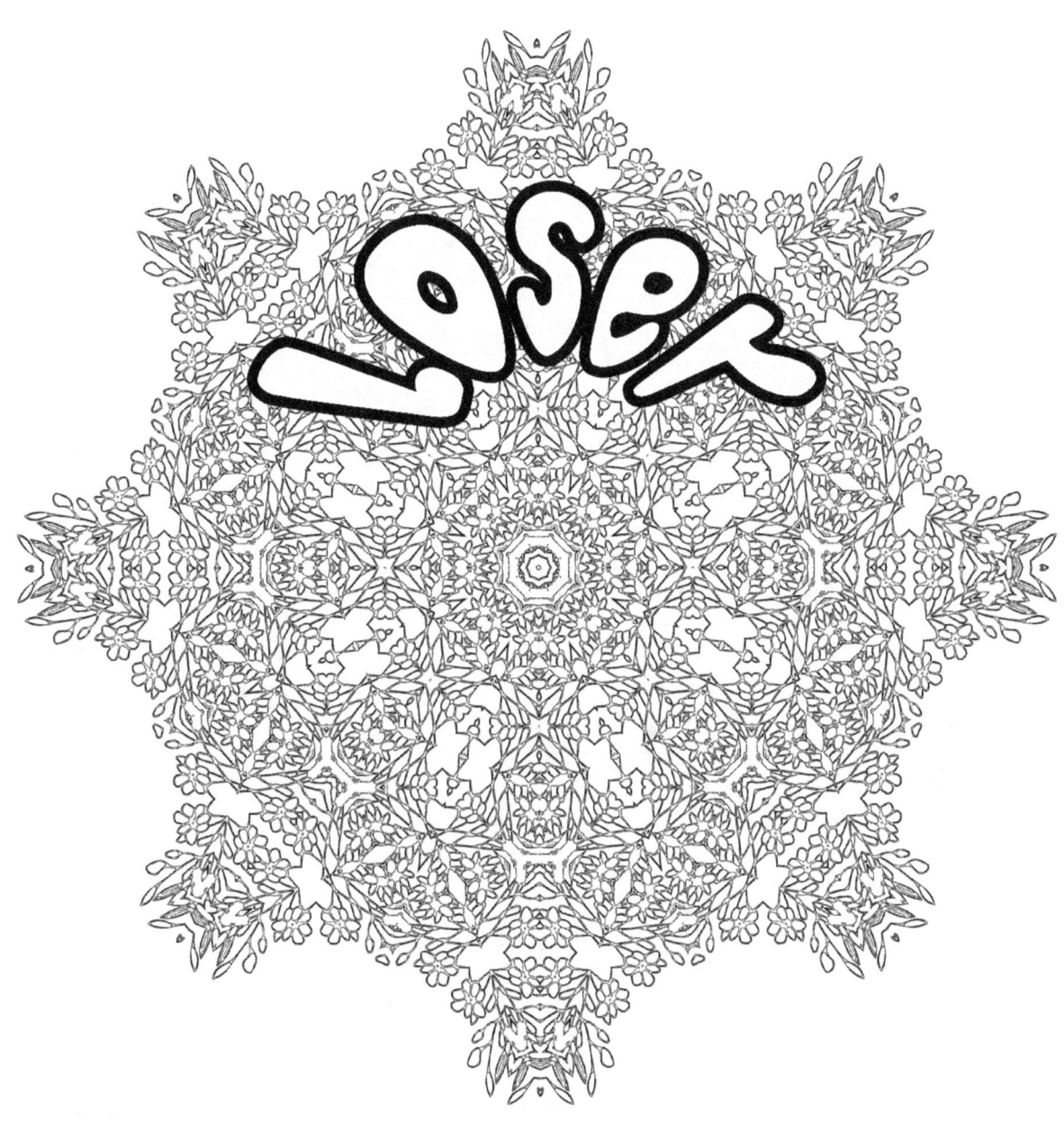

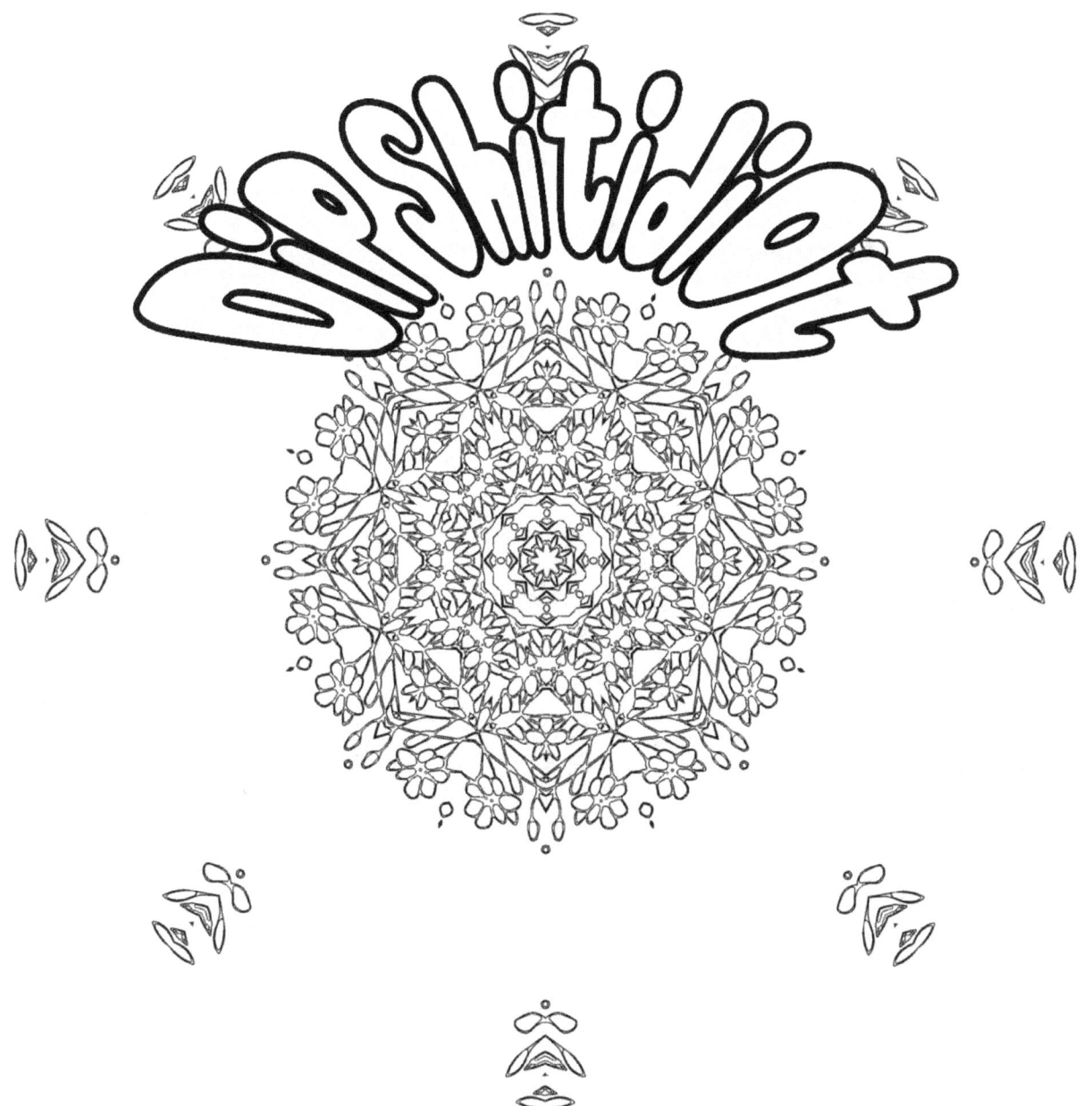

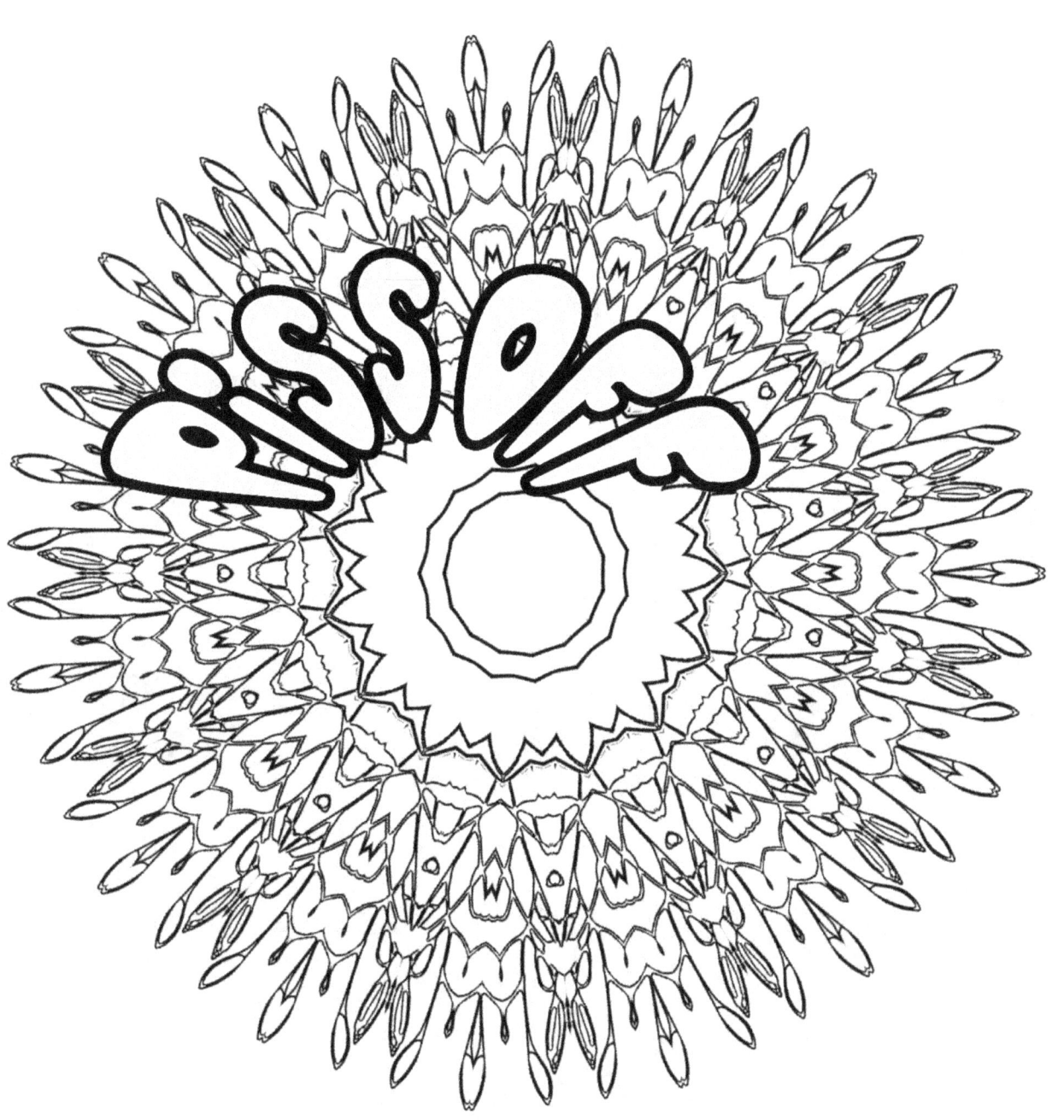

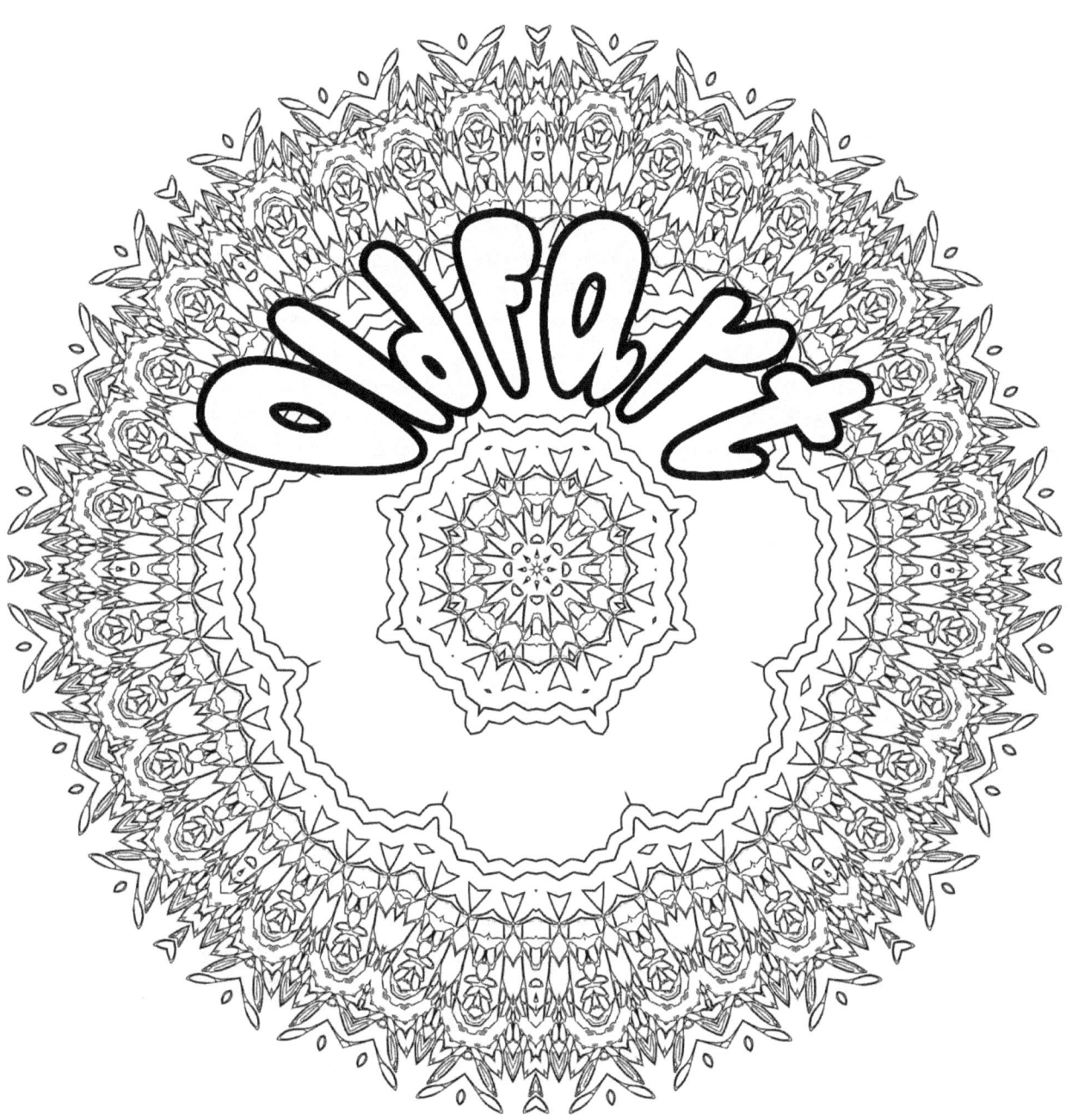

www.ingramcontent.com/pod-product-compliance
Lightning Source LLC
Chambersburg PA
CBHW081131180526
45170CB00008B/3067